COLOR ATLAS

COLOR ATLAS

A PRACTICAL GUIDE FOR COLOR MIXING

Author: Harald Kueppers

Translator: Roger Marcinik

BARRON'S

Woodbury, New York • London • Toronto • Sydney

All inquiries should be addressed to:
Barron's Educational Series, Inc.
113 Crossways Park Drive
Woodbury, New York 11797

Library of Congress Catalog Card No. 81-3644
International Standard Book No. 0-8120-2172-X

Library of Congress Cataloging in Publication Data

Kueppers, Harald.
 Color atlas: a practical guide to color mixing.

 Translation of DuMont's Farben-Atlas.
 1. Color—Atlases. I. Title. II. Title: Color
atlas.
QC4952.K8313 535.6′022′2 81-3644
ISBN 0-8120-2172-X AACR2

PRINTED IN UNITED STATES OF AMERICA

345 620 9876543

Table of Contents

This *Color Atlas* is a practical working aid as well as a communications system. It shows the mixing possibilities of three- and four-color printing in uniform gradations. We proceed here in a purely quantitative fashion because the interval from one quantitative step to the next is always only 10%.

This gives us a reference work that shows more than 5,500 hues in systematic order, an astonishingly large number considering that expensive color atlases usually contain no more than 500 to 1,000 hues at prices of up to $500. Of course, there the hues are defined with scientific precision and the high price results from the closeness of permitted tolerances (range of color deviations).

In selecting any single hue in this *Color Atlas,* a homemade mask of gray paper or cardboard should be used to cover the surrounding hues. This is the only way to eliminate the effect of the surrounding colors if we wish to judge reliably the appearance of the individual hues.

Naturally, one must keep in mind that the appearance of the hues in the charts depends on the quality of the viewing light (that is on its spectral composition). Therefore, when the code numbers given here are used as a means of communication, it should be assumed that observation took place under conditions specified in the ANSI (American National Standards Institute) PH-2.32-1972 Standard for Viewing Conditions for the Appraisal of Color Quality (5000° K).

The code number can be easily read off for each hue. We start with the bold black designation at the upper left, over each chart; for example, B_{30}. This value is the same for all hues in one chart. B_{30} is the indication of the component quantities for black. This quantitative indication relates to the percentage dot value in the film that was used to make the printing plate. In this case the dot value is 30%.

The same applies to the other printing inks yellow (Y), magenta-red (M), and cyan-blue (C).

To indicate the quantitative values of each individual printed hue within the code number with two digits, 99 is equated to 100. The code number is determined by reading the value at the upper left in bold print, which applies to the entire chart. Next the pertinent value on the left scale of the chart is read, and finally the value on the lower scale. In this way a three-part code number is obtained, for example: B_{30} M_{80} C_{20}.

This code number is not only the "name" of this hue but also indicates its mixing formula. Like a chemical formula, it provides information about the mixing ratio.

The hue B_{30} M_{80} C_{20} comes about in the course of the printing process because the following surface coverages are present in the offset films used: black 30%, magenta-red 80%, and cyan-blue 20%. In addition to that, of course, we also have the remaining surface of white paper that is left over.

The U.S. "Standard Offset Color References" from the American Photoplatemakers Association, 552 West 167th Street, South Holland, Illinois 60473, were used for printing this *Color Atlas*. This is why these code numbers should be called "U.S. Standard Color Code" or simply "Standard Color Code."

In printing the color charts, the recommendations in "Specifications Web Offset Publications" from the American Association of Advertising Agencies, the American Business Press, and the Magazine Publishers Association, dated 1978, were observed. However, in applying the code numbers it must be considered that quantitative variations will inevitably occur in each printing ink during a production run, due to printing tolerances. Therefore minor color deviations must be accepted.

We must also keep in mind that in time the appearance of the hues can change due to external influences such as humidity, heat, or fumes. In particular, the color charts must be protected against constant exposure to light.

Therefore anyone using the color charts in this *Color Atlas* regularly and frequently and as means of communication

should obtain a new copy every two or three years, if necessary.

But everyone must realize that, in this type of reasonably priced paperback edition, the accuracy of the hues reproduced cannot meet precise scientific requirements. That, after all, is not the purpose of this work.

This book is not intended to be a work on color theory, but rather a practical working aid and illustrative guide that anyone can afford. This is why the theoretical explanations have been placed at the end of the book. They are intended for the reader who would like to obtain precise information on the theoretical interrelationships which are the basis of this system and the scientific background.

But the reader who does not (or does not yet) wish to address himself to this theory can simply disregard these theoretical explanations. He will therefore not be hindered in any way in using the charts and the Standard Color Codes. Moreover, he will find it possible, by simply studying the color relations in the charts, to gain an essential insight into the laws of color mixture and to discover color theory by his own observation.

This book realizes the author's idea of comparing the "achromatic mixture" with the "chromatic mixture." By "achromatic mixture" we mean that the achromatic values of a hue are formed as much as possible by component quantities of black and white. In the chromatic mixture, on the other hand, the achromatic values result from the fact that the color quality of complementary basic colors is mutually neutralized.

Both mixing principles are illustrated systematically: the achromatic mixture in parts 1, 2, and 3, the chromatic mixture in parts 4 and 5. This introduces for the first time in the history of color theory the interesting possibility of conducting thorough comparisons. But the individual who does not want to cut up his book for this purpose should have a second copy available, if he places special emphasis on this comparison. Or the reader can use the color charts with the chromatic mixture in the appendix to the book by the same author entitled *Farbe—Ursprung, Systematik, Anwendung* [*Color—Origin, System, Uses*] (third edition, Munich, 1977).

Color charts for the achromatic mixture with the black

structure can be recognized by the fact that the quantitative designations applicable to the entire chart start in the upper left-hand corner with a B. These charts in parts 1, 2, and 3 are significant because they demonstrate systematically that this mixing principle can be applied in practice. The charts clearly prove the great superiority of "mixing with achromatic structure" over "mixing with chromatic structure." In addition, this mixing principle with the achromatic structure offers worthwhile technological and economic advantages and greater procedural stability not only in multicolor print. It also offers the same advantages for mixing opaque colorants in industrial, craft, and artistic applications.

In principle, it is possible to apply the Standard Color Code to other mixing systems and derive mixing formulas for other processes. Readers who are particularly interested in these questions might study the corresponding explanations at the end of the book.

The latest research findings have revealed that a so-called "standard observer able to see all colors" can distinguish up to a million hues. The approximately 4,000 hues in the charts with the black structure, of course, are only a small portion of that. Therefore a very specific hue may not always be found exactly in these charts because the hues shown are only a systematic selection from that large number.

Nor can one expect to find a hue precisely that was selected in the charts with the chromatic structure in charts with the achromatic structure, since this hue may lie between existing hues. But the corresponding spot can always be found through interpolation (estimation).

We get a clear overview as a result of the consistent quantitative gradation in steps of 10%. But at the same time we must accept a disadvantage, in the form of a distortion of the sensory intervals between the hues. The sensory intervals are relatively great especially in the initial squares (B_{00}), in charts with the achromatic structure, and they are hardly recognizable in squares with the black ink (B_{99}) covering the entire surface.

For the sake of proper order it must be pointed out that we naturally can find only those hues in the color charts that can be produced in the printing process by mixing the printing inks as specified in the U.S. "Standard Offset Color References." These printing inks are yellow (Y), magenta-red (M), cyan-blue (C), and black (B) and, as we know, do not have the theoretically ideal properties of ideal basic colors. This is why not all visible hues will be found in this *Color Atlas*. There are purer and more intense hues, especially in the color ranges of violet-blue, green, and orange-red.

The names commonly used for colors in everyday conversation generally do not refer to a precise hue but rather to broad color ranges. Red cabbage is not red, but rather violet. And "red hair" in reality is usually not red at all but rather light brown or brown. Likewise, imaginary names that one might come up with in the most varied sectors of industry are basically not of much help. They cannot be more than just an in-house means of communication. The following incident might serve to illustrate this.

Several shoe specialists, producers, and wholesalers happened to be sitting around a table in a Vienna café. They were discussing the colors that happened to be in vogue for shoes. It turned out that the "Bali Brown" of one producer was an entirely different brown color from the "Bali Brown" of the other producer. One wholesaler, on the other hand, pointed out that the colors that one manufacturer called "Mandarin" and the other called "Kalahari" were identical in appearance.

This accidentally overheard conversation is indicative of the communication problems that exist in all areas of color application, be it in the textile industry or in the paint industry, in the production of synthetics or in the manufacture of pigments, not to mention the terminology for artists' colors, which are often nothing more than in-house product names.

These few examples might serve to show how impossible it is to come anywhere near naming hues in an accurate manner, without confusion, by using the instruments of language. This is why the Standard Color Code numbers offered here can in

many cases become a practical means of communication. To be sure, as we said before, they cannot meet exact scientific requirements due to the printing tolerances that are necessarily present in multicolor printing. But in most cases a greater accuracy is not necessary anyway. And the problem is relatively minor in the sections on the achromatic mixtures in this book.

The communication possibilities resulting from the Standard Color Code are much better and are more precise than those offered by language could ever be. We shall see whether they can perform the function intended for them on a broad basis.

One should not be surprised by the fact that this code number initially looks abstract. It is *not* abstract, because it refers very specifically to a practical application in the field of multicolor printing. This is why, after some practice, anyone will be able to visualize something very concrete in connection with a given color code.

After all, telephone numbers were also something incredibly abstract when the telephone system was first introduced. Today it is quite natural for anyone who must make frequent phone calls to connect specific concepts with a certain telephone number. If children were to learn the system of Standard Color Codes in school, they would use those numbers within a foreseeable period of time just as naturally as telephone numbers.

We need color names only for the eight basic colors, so that color code numbers can be related to them meaningfully. But widely differing names are being used for these eight basic colors in the various specialized fields and branches; hence it is common sense to arrive at a universal terminology. The names for these eight basic colors must on the one hand be correct and accurate, while on the other hand they must not be subject to any confusion. In addition, they should not conflict with the customs of everyday language.

Regarding the "correct" designations for basic colors, Louis Cheskin, Director of the Color Research Institute of America, submits an interesting proposal which is in line with all major

arguments (in: *Cheskin Color Chart,* The Macmillan Company, New York, 1954). In keeping with this proposal (only saying "cyan-blue" instead of his "green-blue") the eight basic colors in this book are given the following color names (see color chart, p. 17):

White	(W)
Yellow	(Y)
Magenta-red	(M)
Cyan-blue	(C)
Violet-blue	(V)
Green	(G)
Orange-red	(O)
Black	(B)

Because in the blue area as well as in the red area there are two different basic colors, to only say "blue" or "red" does not give the wanted precision, for nobody will know exactly which basic color is meant.

Seeing is an indirect process. "Color" originates as a sensation. Light rays are merely transmitters of information. The eight basic colors are no more than the eight extreme color sensations that the eye can produce. Color mixing laws are the possible interpretations of that higher law according to which the eye functions.

In color photography, the chromatic basic colors yellow, magenta-red, and cyan-blue are present as filter layers. They modulate the quantity of light that is allowed to pass for each point on the picture. The white light necessary for the projection or observation of a color slide represents the achromatic basic color white. Every filter layer absorbs a portion of that light. Due to the interaction of the filter layers in front of white, the four missing basic colors arise from the four existing ones. Specifically, the three chromatic basic colors violet-blue, green, and orange-red always materialize when two filter layers are completely superimposed at one point in the picture. Picture points in which all three filter layers are completely present appear black.

Color television works according to a law that could be called "complementary" to the law of color photography. Here, the chromatic basic colors violet-blue, green, and orange-red are present as color lights whose intensity can be varied for each picture point. To make the interaction of these color lights visible, it is essential to have the achromatic basic color black as a foundation. This color is represented by the darkness in the cabinet of the television set. The three missing chromatic basic colors originate where any two of the chromatic color lights interact completely. The achromatic basic color white appears at those picture points where all three color lights meet fully.

An artist working with opaque media—for example, with oil paints—however, needs all eight basic colors. For him there are basically various possibilities for mixing the desired hue. On the one hand, he can build on the achromatic value—in other words, on the gray amount used as foundation—and he can add quantity components of the chromatic basic colorants that are necessary to give the hue its chromatic appearance. This corresponds to the color charts in parts 1, 2, and 3. In this connection we must, however, keep in mind that the component quantities of two chromatic printing inks must be replaced by one component quantity of a third basic color when mixing opaque colorants. In place of the corresponding two component quantities of yellow and magenta-red, for example, we may now use only one component quantity of the basic color orange-red for our mixing purposes.

On the other hand, the artist naturally can also obtain hues by means of chromatic mixing. This basically corresponds to the color charts in parts 4 and 5. But here again he needs the basic colors white and black just as much as the basic colors violet-blue, green, and orange-red, assuming that he is working with opaque colorants that are coordinated with each other, that he is mixing first, and that he is using only one single opaque layer of paint.

We had five of the eight basic colors available as initial factors in assembling this book of charts in multicolor print.

The surface of the printing paper represents the basic color white. In addition we have the printing inks black, yellow, magenta-red, and cyan-blue. Since the chromatic printing inks involve transparent filter layers, the basic colors violet-blue, green, and orange-red will also materialize by printing when two color layers come together fully, that is, when the absorption possibilities of any two filter layers are added up.

We wanted to describe this situation here quite briefly so that the reader realizes that we are always dealing with eight basic colors; particularly since in certain reproduction systems (color photography, color television, color printing), it initially seems that three basic colors are sufficient to mix all of the other hues.

This book might serve as a proposition for a common American Printing Standard Web Offset. The details are the following:

Screen: 150 L

Inks and densities: As Standard Offset Color Reference from the American Photoplatemakers Association, 552 West 167th Street, South Holland, Illinois 60473.

Color Control: As noted in the G.A.T.F. *Research Progress* number 76

Dot lost in platemaking (in the middletone 40%): 7% (tolerance ± 2%)

Dot gain in printing (against the 40% field of G.A.T.F. Standard Offset Color Control Bar): 18% (tolerance ± 3%)

Proofing paper: Quality equal to Consolidated Paper Company's 60# Fortune Gloss

Eight Basic Colors

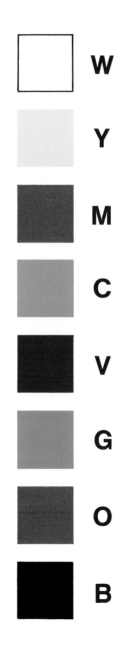

W

Y

M

C

V

G

O

B

COLOR CHARTS

Part 1 | ***Achromatic Mix with Black***
 | ***Violet-Blue Range***

B$_{00}$

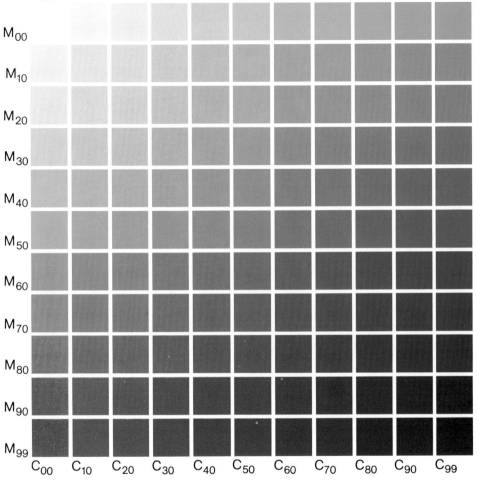

B₁₀

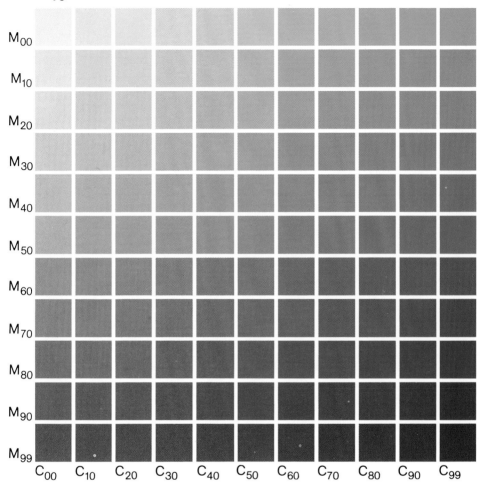

B₂₀

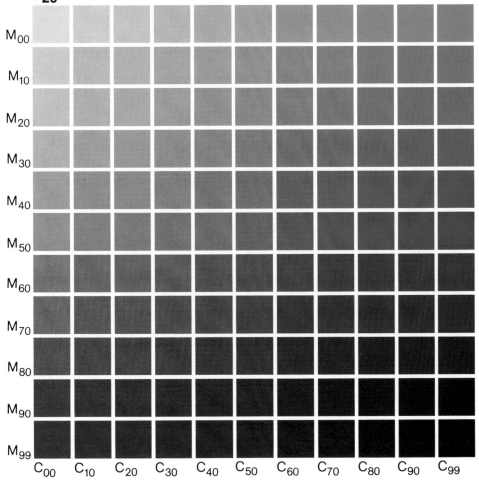

B₃₀

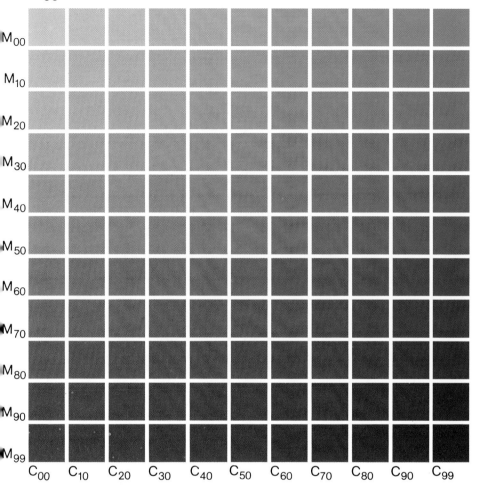

M_{00}
M_{10}
M_{20}
M_{30}
M_{40}
M_{50}
M_{60}
M_{70}
M_{80}
M_{90}
M_{99}

C_{00} C_{10} C_{20} C_{30} C_{40} C_{50} C_{60} C_{70} C_{80} C_{90} C_{99}

B₄₀

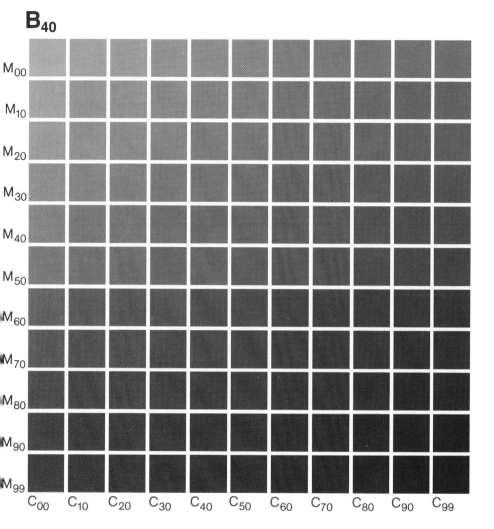

B₅₀

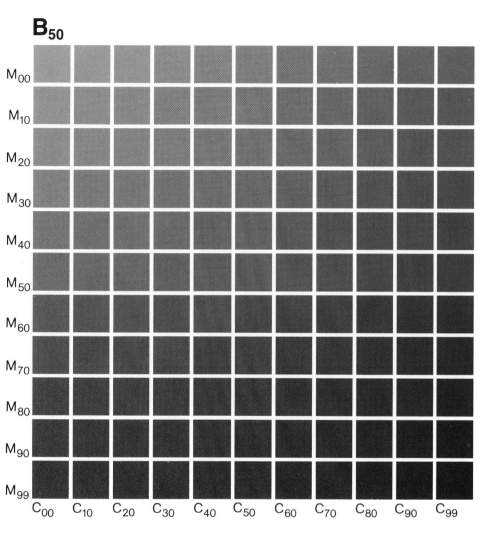

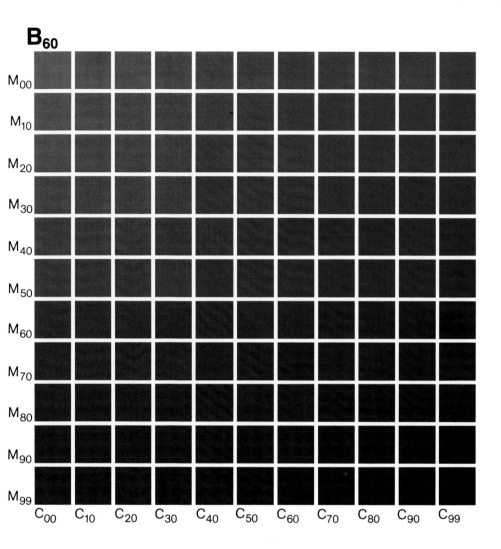

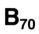

B₇₀

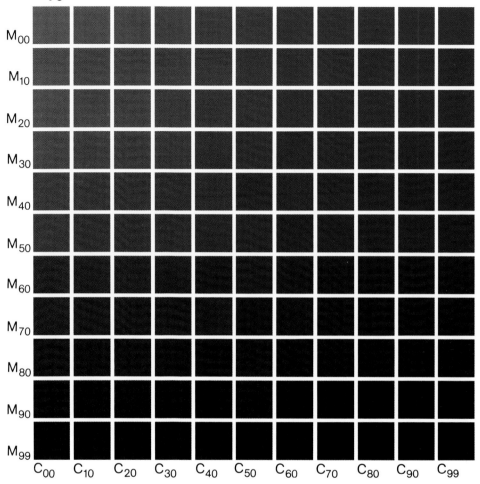

B₈₀

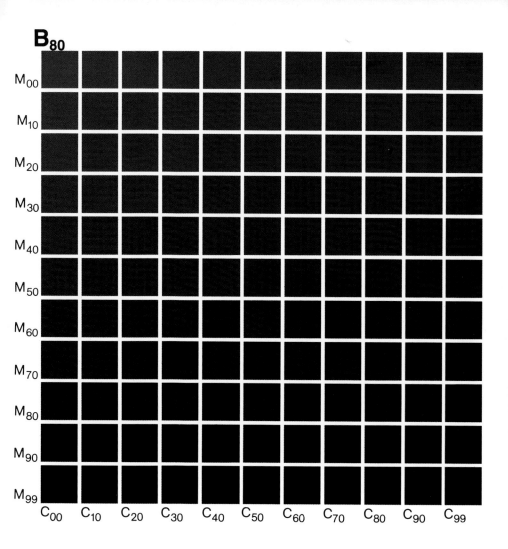

B90

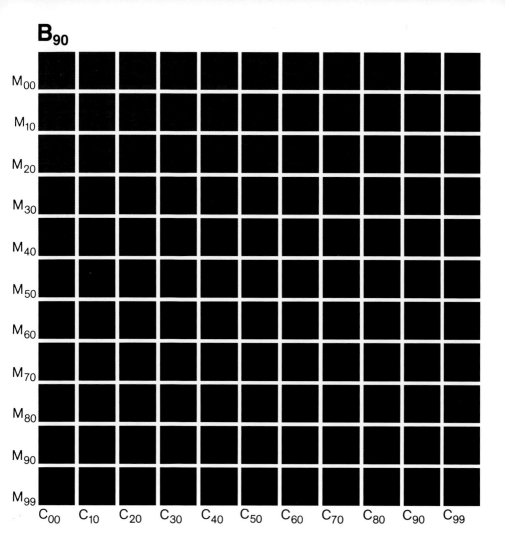

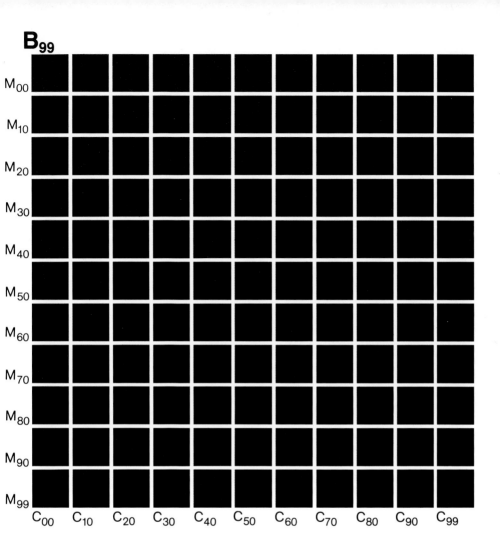

B_{99}

M_{00} M_{10} M_{20} M_{30} M_{40} M_{50} M_{60} M_{70} M_{80} M_{90} M_{99}

C_{00} C_{10} C_{20} C_{30} C_{40} C_{50} C_{60} C_{70} C_{80} C_{90} C_{99}

Part 2 | *Achromatic Mix with Black*
Orange-Red Range

B₀₀

B_{00}

Color chart with rows labeled Y_{00}, Y_{10}, Y_{20}, Y_{30}, Y_{40}, Y_{50}, Y_{60}, Y_{70}, Y_{80}, Y_{90}, Y_{99} and columns labeled M_{00}, M_{10}, M_{20}, M_{30}, M_{40}, M_{50}, M_{60}, M_{70}, M_{80}, M_{90}, M_{99}.

B₁₀

B₂₀

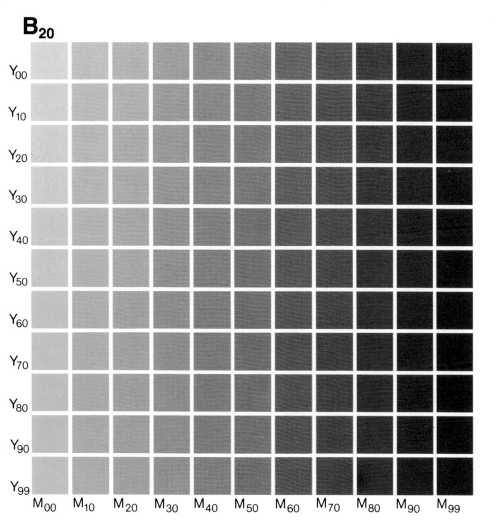

B_30

Y_00 Y_10 Y_20 Y_30 Y_40 Y_50 Y_60 Y_70 Y_80 Y_90 Y_99

M_00 M_10 M_20 M_30 M_40 M_50 M_60 M_70 M_80 M_90 M_99

B$_{40}$

Color chart with rows labeled Y$_{00}$, Y$_{10}$, Y$_{20}$, Y$_{30}$, Y$_{40}$, Y$_{50}$, Y$_{60}$, Y$_{70}$, Y$_{80}$, Y$_{90}$, Y$_{99}$ and columns labeled M$_{00}$, M$_{10}$, M$_{20}$, M$_{30}$, M$_{40}$, M$_{50}$, M$_{60}$, M$_{70}$, M$_{80}$, M$_{90}$, M$_{99}$

B₅₀

B₆₀

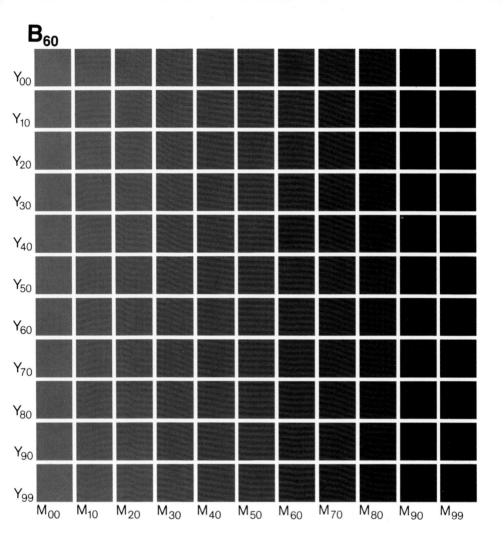

B₇₀

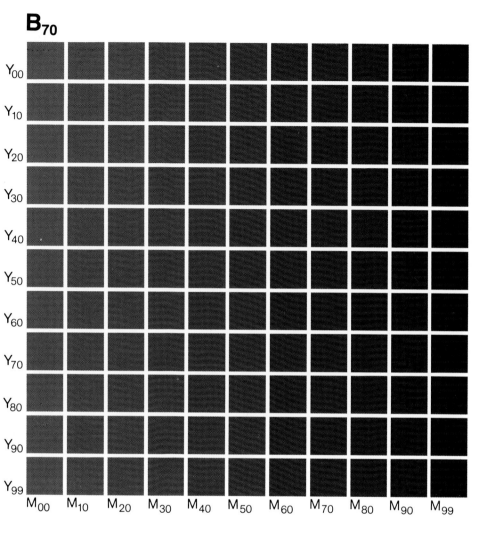

B₈₀

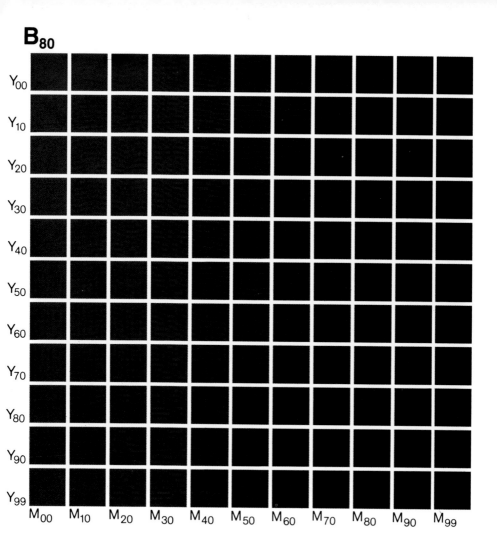

B$_{90}$

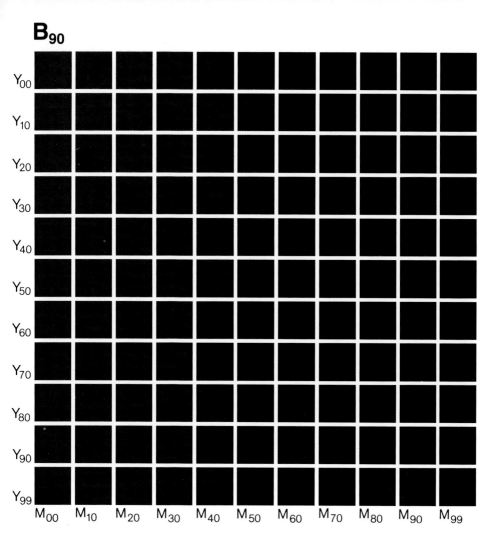

Y$_{00}$ Y$_{10}$ Y$_{20}$ Y$_{30}$ Y$_{40}$ Y$_{50}$ Y$_{60}$ Y$_{70}$ Y$_{80}$ Y$_{90}$ Y$_{99}$

M$_{00}$ M$_{10}$ M$_{20}$ M$_{30}$ M$_{40}$ M$_{50}$ M$_{60}$ M$_{70}$ M$_{80}$ M$_{90}$ M$_{99}$

63

B₉₉

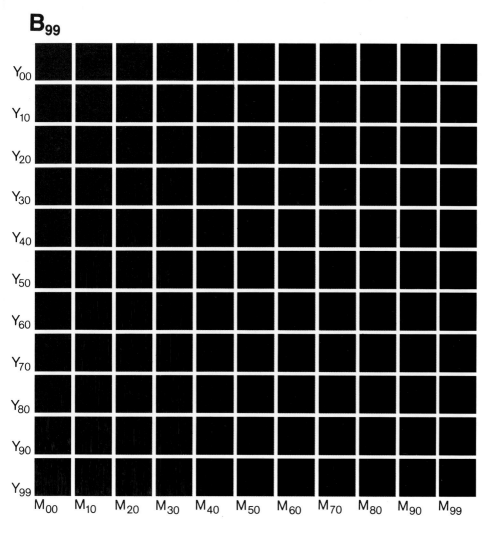

Part 3 | **Achromatic Mix with Black**
Green Range

B₀₀

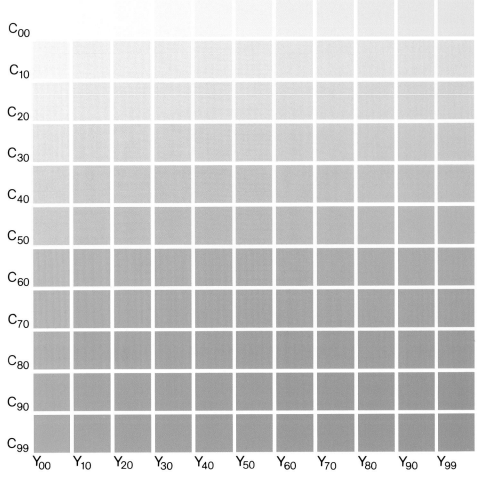

B$_{10}$

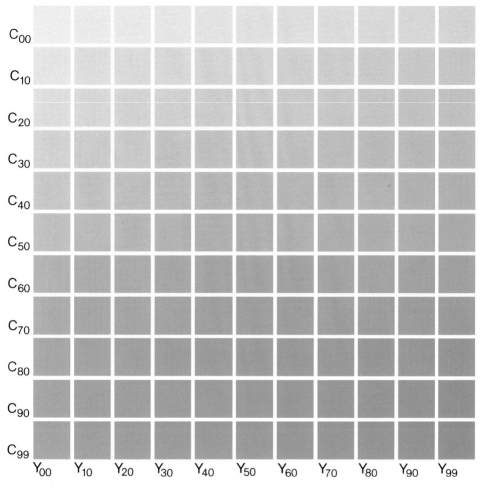

C$_{00}$ C$_{10}$ C$_{20}$ C$_{30}$ C$_{40}$ C$_{50}$ C$_{60}$ C$_{70}$ C$_{80}$ C$_{90}$ C$_{99}$

Y$_{00}$ Y$_{10}$ Y$_{20}$ Y$_{30}$ Y$_{40}$ Y$_{50}$ Y$_{60}$ Y$_{70}$ Y$_{80}$ Y$_{90}$ Y$_{99}$

B₂₀

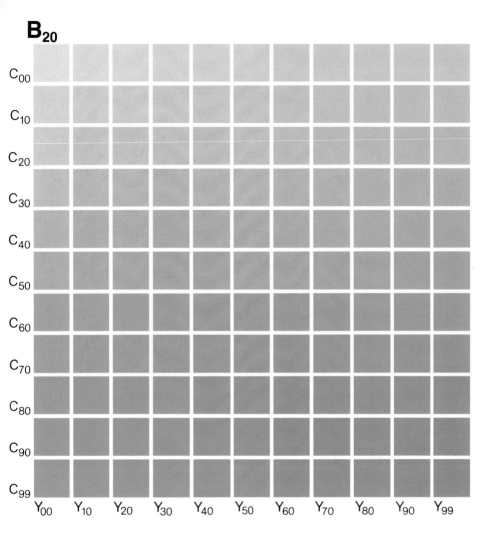

B₃₀

Color chart with rows labeled C_{00}, C_{10}, C_{20}, C_{30}, C_{40}, C_{50}, C_{60}, C_{70}, C_{80}, C_{90}, C_{99} and columns labeled Y_{00}, Y_{10}, Y_{20}, Y_{30}, Y_{40}, Y_{50}, Y_{60}, Y_{70}, Y_{80}, Y_{90}, Y_{99}.

75

B₄₀

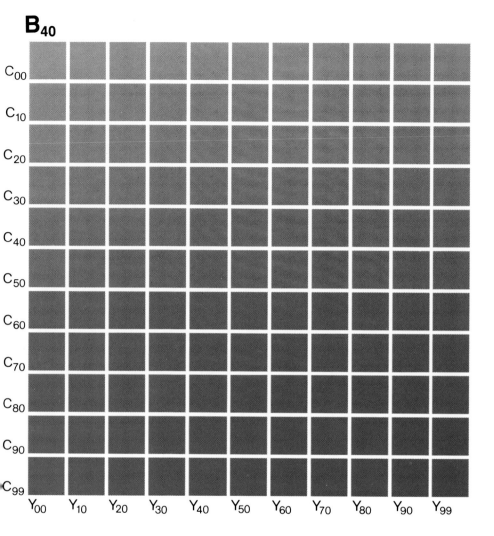

B₅₀

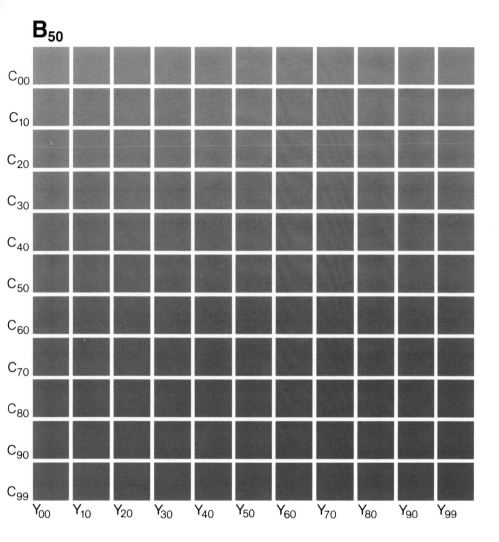

B$_{60}$

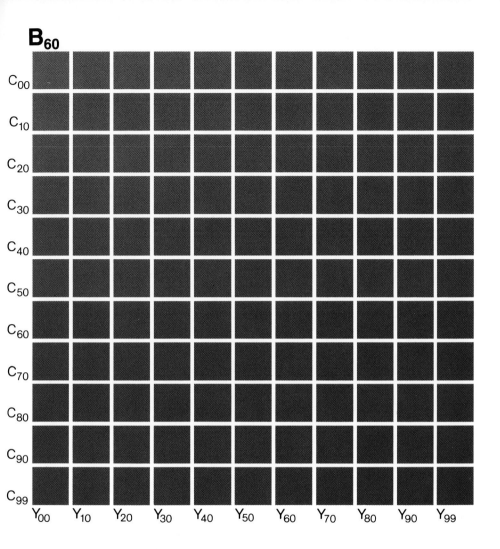

B₇₀

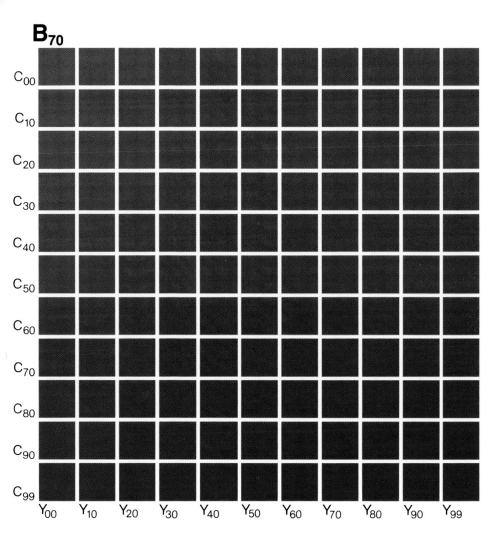

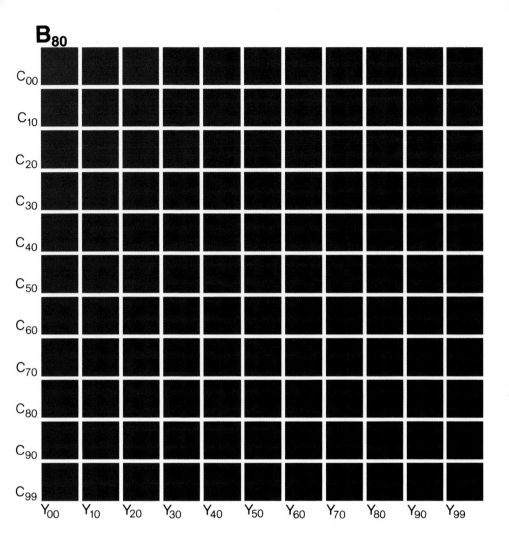

B₉₀

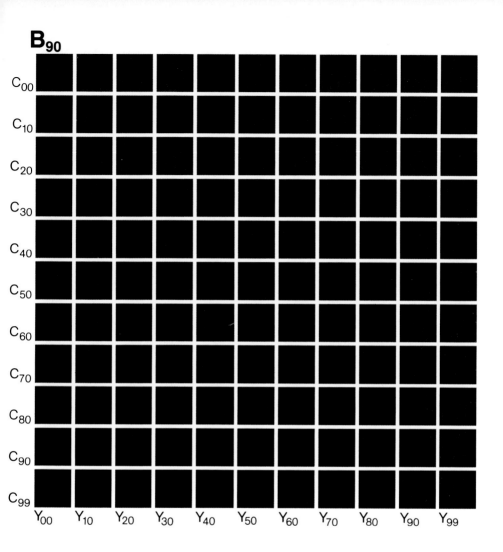

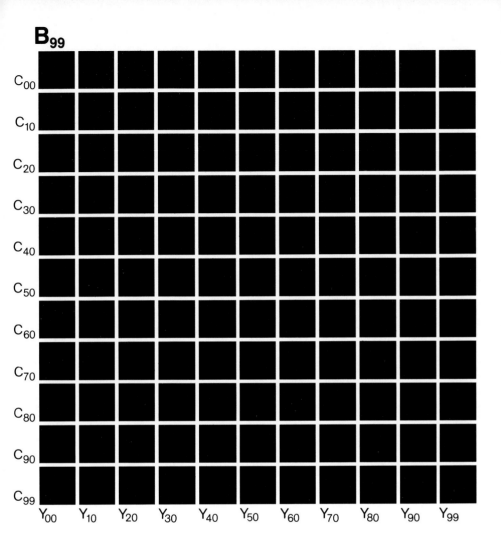

Part 4 | *Chromatic Mix with Yellow*
Three-Color Structure

Y$_{00}$

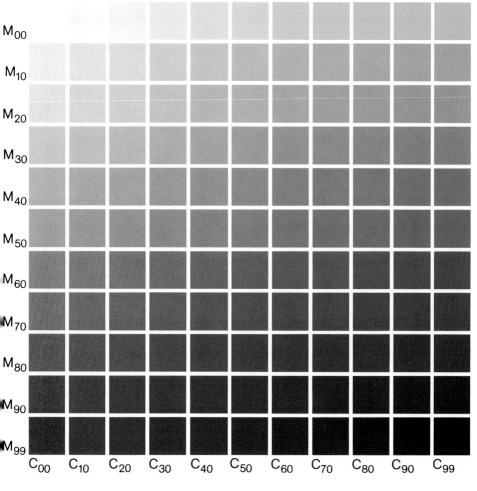

M$_{00}$ M$_{10}$ M$_{20}$ M$_{30}$ M$_{40}$ M$_{50}$ M$_{60}$ M$_{70}$ M$_{80}$ M$_{90}$ M$_{99}$

C$_{00}$ C$_{10}$ C$_{20}$ C$_{30}$ C$_{40}$ C$_{50}$ C$_{60}$ C$_{70}$ C$_{80}$ C$_{90}$ C$_{99}$

Y$_{10}$

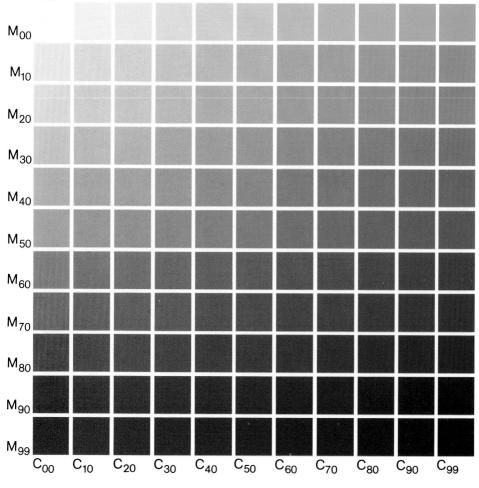

Y$_{20}$

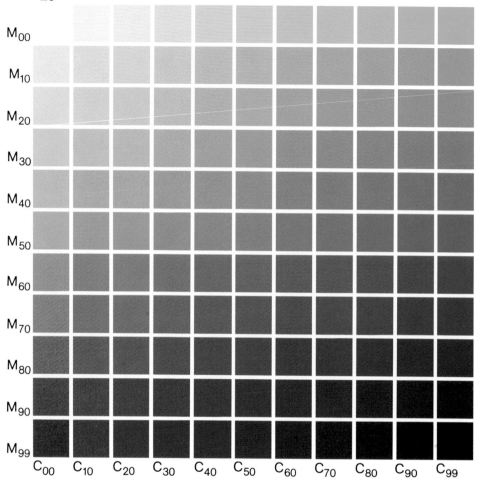

Y₃₀

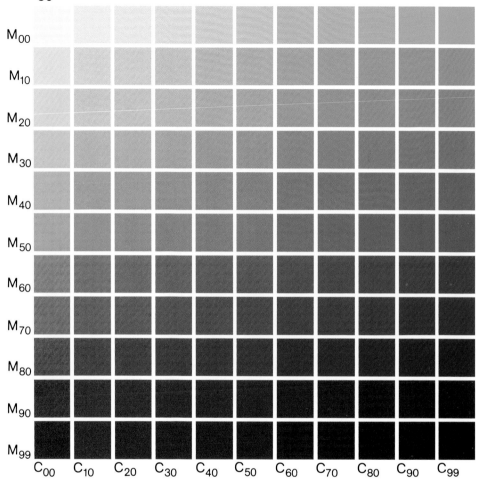



Y₄₀

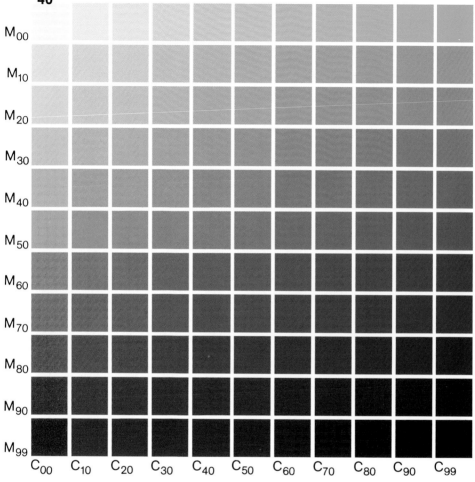

Y$_{50}$

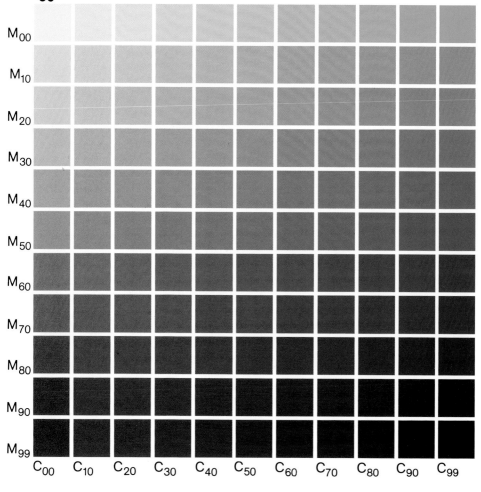

Y₆₀

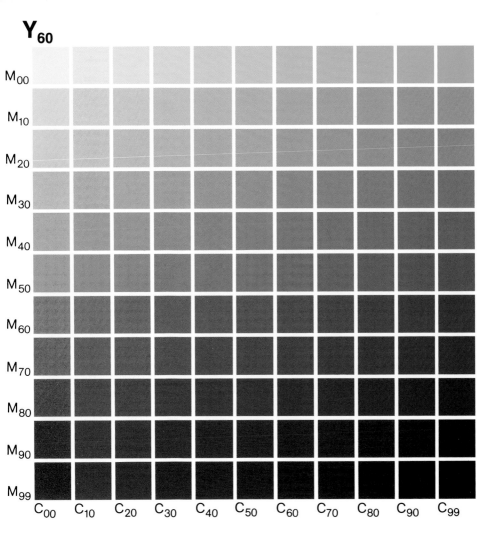

Y$_{70}$

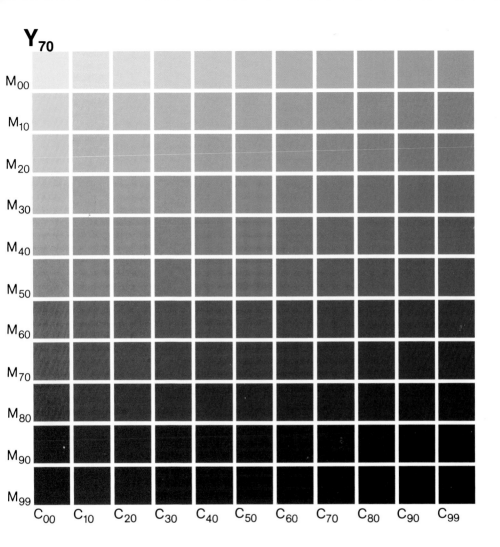

Y₈₀

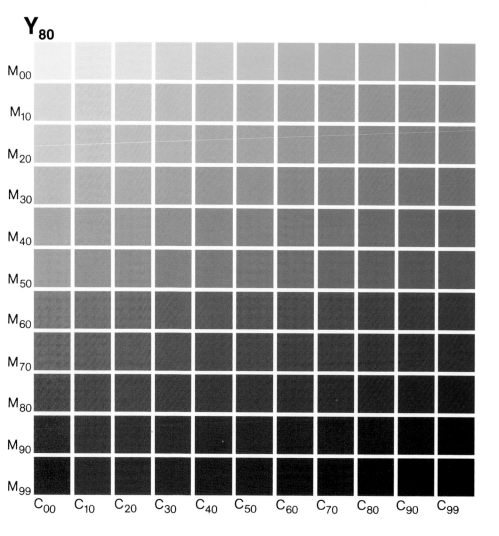

Y$_{90}$

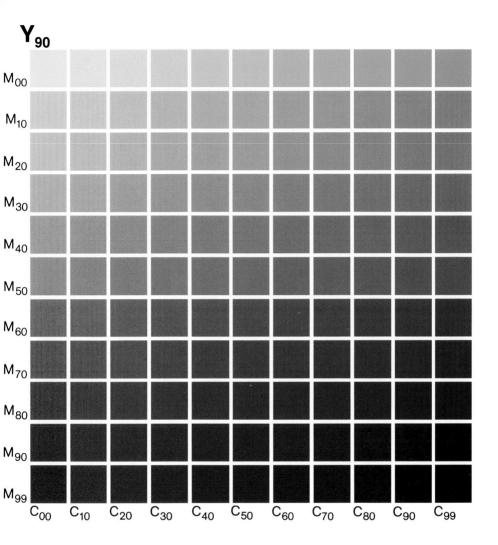

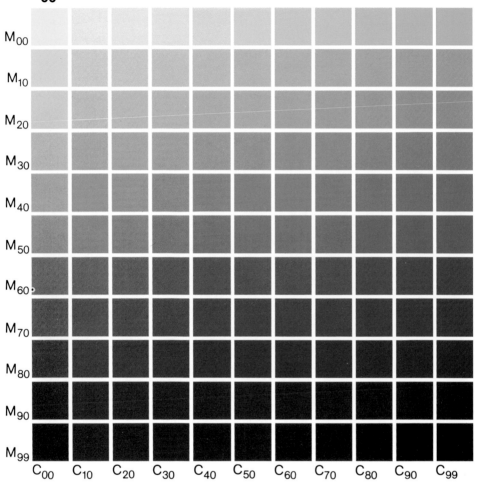

Part 5 | *Chromatic Mix*
Three-Color Structure
Additional Charts M_{99} and C_{99}

M99

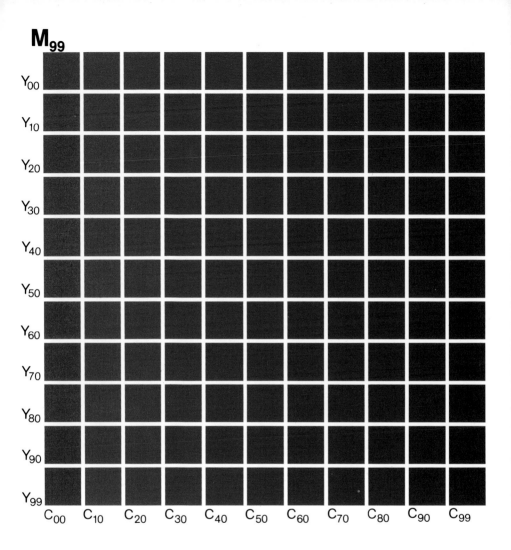

Y00 Y10 Y20 Y30 Y40 Y50 Y60 Y70 Y80 Y90 Y99

C00 C10 C20 C30 C40 C50 C60 C70 C80 C90 C99

C₉₉

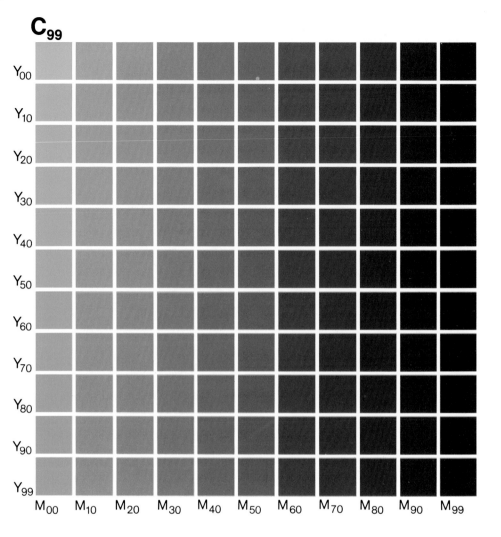

THEORETICAL EXPLANATIONS

1 | *Color Charts of Achromatic Mix with Black*

The point of departure for this three-part volume of charts is the surface of the color hexagon (see color chart, p. 129). This is a systematic, quantitatively patterned arrangement. The six chromatic basic colors are placed at the six corners of the hexagonal surface. The achromatic basic color white is at the center. There are continual transitions between these seven basic colors.

This book was printed by offset. For multicolor printing, the chromatic basic colors yellow (Y), magenta-red (M), and cyan-blue (C) are normally used. They are applied to paper as transparent chromatic filter layers. The achromatic basic color white (W) is represented by the white paper surface. Where no ink prints, the achromatic basic color W remains effective.

The systematic quantitative arrangement of the three basic colors Y, M, and C in the color hexagon can be seen in figures 1, 2, and 3. In figure 1 we can see how each hue has the quantitative value Y_{99} on the hexagon sides OY and YG. Here, in other words, the basic color Y is present as a full color layer. Therefore, this quantity line is labeled Y_{99}. We can trace how the values diminish toward the line Y_{00}, resulting in a gradual quantitative reduction for this basic color. In the rhombus WCVM there are no longer any quantitative values of the chromatic basic color Y.

What we said about basic color Y with relation to figure 1 applies likewise to the basic color M in figure 2 and the basic color C in figure 3.

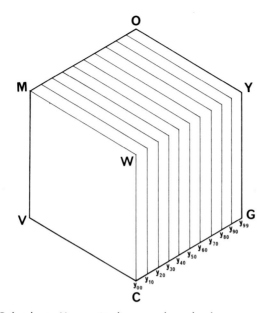

1 Color layer Y quantity lines on the color hexagon surface

2 Color layer M quantity lines on the color hexagon surface

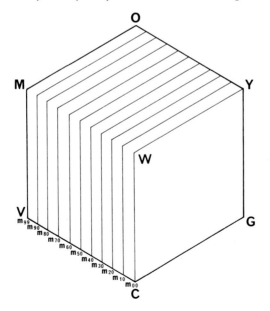

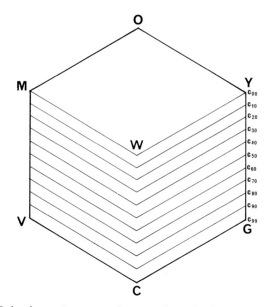

O

M
Y

C_{00}
C_{10}
C_{20}
C_{30}
C_{40}
C_{50}
C_{60}
C_{70}
C_{80}
C_{90}
C_{99}

W

V
G

C

3 Color layer C quantity lines on the color hexagon surface

In figure 2, the hues with quantitative value M_{99} are on the hexagonal sides OM and MV. The quantitative value of M decreases regularly toward line YWC until it attains the value M_{00}. The basic color M is no longer represented in the rhombus WCGY.

Finally, figure 3 shows the quantitative arrangement for the chromatic basic color C. The hues with the quantitative value C_{99} are to be found on line VCG. The quantitative values decline continually toward line MWY and attain the value C_{00} here. The chromatic basic color C is no longer represented in the rhombus WMOY.

The numerical diagram in figure 4 shows what was explained in figures 1, 2, and 3 individually for each printing ink used. Here the color hexagon surface (see color chart, p. 129), is represented by quantitative formulas. At the center of the numerical diagram is the hue W_{99}. This is the achromatic basic color W. This W_{99} is intended to remind us that the white

123

paper surface remains effective where no further quantity components of the chromatic basic colors used were added. (The particularly critical reader might be advised that the ideal conditions described above and shown in figure 4 could not be realized exactly in the color hexagon printed here, for technical reasons.)

A careful study of the numerical diagram shows that there are three rhomboidal zones in which the mixing possibilities of any two chromatic printing inks are arranged systematically. This naturally follows from what was said before. But it is still very informative to have the interaction of the three chromatic printing inks so clearly represented.

Geometrically, the hexagonal surface naturally consists of an infinite number of points, of which a systematic selection is defined by the quantitative formulas in figure 4. For the sake of greater clarity, the two quantitative values that apply to one given point are no longer next to each other, but one under the other. The quantitative values for the effective remaining surface of the white paper are omitted.

Not only the study of the quantitative interrelationships on the color hexagon surface is of interest. A comparison of the color hexagon and the numerical diagram in figure 4 also shows the qualitative arrangement.

The achromatic arrangement is shown in figure 5. The achromatic value (A) is highest at the center because that is the spot for the achromatic basic color white. The quantitative value A_{99} and the quantitative value W_{99} are identical in this case. (However, later on we will see that the achromatic value can be filled out by every mixing ratio between the achromatic basic colors white [W] and black [B].)

Figure 5 shows the achromatic degree lines in the area of the color hexagon and of the numerical diagram in figure 4. The achromatic value in the color hexagon derives from the differential value of the paper surface that remains effective. Only where at least one of the initial chromatic printing inks Y or M or C is present with a quantitative value of 99 does nothing of the paper surface remain effective, so that the

4 Numerical diagram of quantitative distribution in the hexagonal surface in case of three-color printing and color photography

achromatic basic color W is no longer represented as a quantity. This is the case on the outside line of the hexagonal surface in figure 5. It is therefore labeled with A_{00}. On that line we find the hues without achromatic value.

The achromatic value and the chromatic value are reciprocal

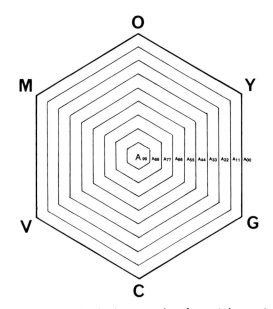

M Y

A_{99} A_{88} A_{77} A_{66} A_{55} A_{44} A_{33} A_{22} A_{11} A_{00}

V G

C

5 Achromatic arrangement in the hexagonal surface. Achromatic degree lines, respectively, chromatic degree lines

magnitudes. Both of them together always give us the mathematical quantity one, respectively, 100%. The smaller the achromatic value, the greater the chromatic value. The same applies conversely. Therefore, achromatic degree lines are those that run parallel to the outside line of the color hexagon surface.

In figure 6 we find the chromatic type arrangement (color hue arrangement) of the color hexagon surface. Every point on the hexagon sides represents one chromatic type (color hue). Chromatic type lines are straight connecting lines between the center of the hexagon and any desired point on a hexagon side. In the numerical diagram in figure 4, the quantitative ratio of the component quantities of the two chromatic basic colors remains constant on chromatic type lines. For example, on the chromatic type line running from the center W_{99} to the chromatic type hue $M_{99} C_{99}$, the ratio between the component quantities of M and C is always 1:1.

6 Chromatic type arrangement in the hexagonal surface with chromatic type lines

However, of the eight basic colors that exist (basic colors represent the extreme sensation possibilities of the visual organ), we can find only seven in the surface of the color hexagon. They are the six chromatic basic colors and the achromatic basic color W. In other words, we do not have the achromatic basic color black (B) here. This means that in the system of our hexagon achromaticity is present not as a dimension, but only as a geometrical point. This is because the achromatic dimension is a straight line running between the achromatic basic colors W and B, referred to as the "gray scale" or the "achromatic axis."

Figure 7 points up this situation. All achromatic quantities on our hexagon surface are filled out by the achromatic basic color W. But they could also be "occupied" by the achromatic basic color B. However, any mixing ratio between W and B—in other words, any gray step—would be conceivable. Here we clearly see that it is impossible to arrange the vast number of

7 The achromatic dimension is missing in the hexagonal surface. It is indicated by the broken line WB. This dimension is identical to the gray scale.

all visible hues into a coherent order on a two-dimensional surface. Instead, we need three-dimensional "color space" for this purpose.

On the basis of what was said we would get, as a consequence, the six-sided inverted pyramid in figure 8.* This six-sided pyramid can serve as a "crutch" in understanding a color space since hues with identical component quantities of the achromatic basic color B would lie on horizontal intersecting planes, parallel to the hexagon surface on top. The illustration of these profiles, however, could be accomplished only with extreme technical difficulties. Therefore we shall follow a different, purely pragmatic course.

*See Harald Küppers [Kueppers], *Die Logik der Farbe. Theoretische Grundlagen der Farbenlehre* [*The Logic of Color—Theoretical Foundations of Color Theory*], Munich, 1976, p. 170, fig. 256.

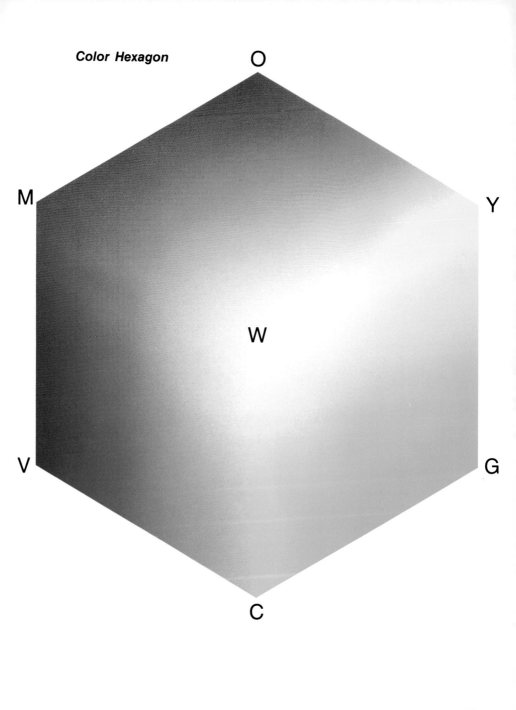

Color Hexagon

8 Hexagonal pyramid with black apex

However, before we can address ourselves to that, we must point out why we spoke in terms of a "crutch." A comprehensive color theory must relate to the perception mechanism of the visual organ. This is because what we call a "color mixing law" is nothing more than the interpretive potential of the law according to which the eye functions. It happens that the ideal color space is the rhombohedron. All forms of color origin, color mixing and color perception can be explained only in the light of such a higher system.*

In contrast to that, we will now confine ourselves to purely practical facts and possibilities. We will take the chromatic basic colors yellow, magenta-red, and cyan-blue, available as printing inks, as they are. In other words, we will take them with all of the flaws they reveal compared to the ideal theoretical requirements and insert them into a purely

*See Harald Kueppers, *The Basic Law of Color Theory* (Woodbury, New York: Barron's, 1982).

quantitatively constructed scheme, i.e., in the form of quantitative steps. Hence, we will not illustrate any ideal theory here. Instead, we will point up the technological possibilities that can be derived from ideal theory as far as multicolor printing is concerned.

It is worldwide custom today to use a chromatic mixture in multicolor printing. This book, however, is also a proof of the fact that this is the worse of two technological possibilities. Color charts with the black structure prove that the conversion to genuine four-color printing will bring enormous technological and economic advantages. Everyone will clearly realize that it certainly makes sense to build up the achromatic values of a particular hue as much as possible on the basis of black. This, by the way, is nothing new; in fact, it was aptly described by Wilhelm Ostwald in the magazine *Die Farbe* [*Color*] (No. 17) in 1921.

If we were to cut the surface of the color hexagon into equilateral triangles, in the manner described in figure 9, we would get 150 different hues, that is, 50 for each of the three rhombus sections. This procedure will be used in handling the color hexagon surface (color chart, p. 129).

These 150 hues would therefore be a selection of the mixing possibilities of neighboring chromatic basic colors among each other and at the same time the mixing possibilities of the resultant chromatic type hues with white.

The achromatic dimension would be completely absent, as we are now well aware. This is because the achromatic values of all hues on the surface of our color hexagon are, after all, "filled out" by the achromatic basic color white. We would thus have to put together a continual series between each one of the 150 hues and the achromatic basic color black.

We could do that theoretically, for example, by putting less and less light on the individual hue until no further light is reflected by it and until it would look black to the observer's eye. Nevertheless, the bright surrounding field would have to be unchanged. This experiment would be very complicated, because it would have to be carried out in a completely darkened room and we would have to have two projectors, one of which would illuminate only the sample while the other one would illuminate only the surrounding field. Both projectors would have to be equipped with stencils so that the projected areas would fit exactly into each other. The projector illuminating the sample would have to be capable of continuous adjustment of light intensity all the way to zero.

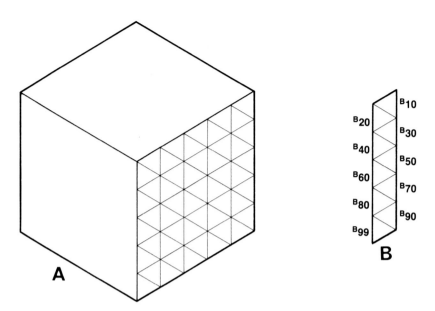

9 50 × 3 × 11 = 1,650 hues. Doubling the number of steps would yield 12,600 hues

But there is another possibility that is just as worthwhile and instructive in demonstrating the three-dimensional nature of color diversity. This is to make a color hexagon surface which should be as large as possible and, as in figure 9A, to subdivide it into 150 equilateral triangles. It is immaterial here whether the surface is laid out with continual transitions or whether each hue appears as a step.

Next we make a mask to cover the colors in the surrounding field so that only a single one of the triangular surfaces remains open. In this way each hue can be observed individually. (The mask should be medium gray.)

The mix toward black can be simulated now with a transparent overlay (figure 9B). It is not important here whether the ten transparent achromatic steps are produced by a half-tone film or by a continuous-tone film. In this system, they would merely have to be in increments of 10%.

10 Subdivision of the color hexagon into three rhombi

Using the previously described mask, each of the 150 hues can be observed individually. With the help of the transparent overlay, we can make each individual hue visible in 11 different steps leading toward black. This is because the hues on the hexagon surface itself correspond to the quantitative value B_{00}. With the ten black steps in the overlay we can thus obtain 1,650 hues.

The two possibilities just described—that is, the variation of the individual hues of the color hexagon by altering the illumination intensity or by superimposing transparent gray steps—is certainly extraordinarily worthwhile for certain instructional purposes. Unfortunately, both concepts are unsuited for the production of our *Color Atlas* in multicolor print.

We must therefore find a different way in order to arrive at a satisfactory technical solution. To do that we return to the color

11 Transformation of the three rhombi into three squares

hexagon surface. In figure 4 we clearly saw that the hexagon surface consists of three rhomboidal zones in which the mixing possibilities of any two of the chromatic basic colors used as printing inks are arranged systematically and quantitatively. These three zones are illustrated in the diagram in figure 10.

As a result of the geometrical transformation of figure 11, we turn the three rhombi in figure 10 into the three squares in figure 12. Thus, for example, the rhombus WMOY in figure 11 is turned into the square WM′O′Y′. This applies likewise to the two rhombi WYGC and WCVM.

It is worthwhile to study how this distortion (figure 13) causes the achromatic value lines and the chromatic type lines in the individual squares to be shifted. Basically of course nothing has changed. The achromatic value lines still run parallel to the corresponding sides. And the chromatic type lines are still straight connections between points on the former external sides of the hexagon and the center.

12 The three squares that resulted from the color hexagon due to transformation

13 Change of chromatic type lines and achromatic degree lines after transformation

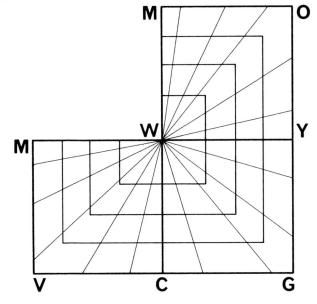

Now we can "take apart" the three squares in figure 12. In figure 14 they are labeled 1, 2, and 3. Each of these three squares is a starting square for our color charts with the black mix. Square number 1 is the starting base for Part 1 of the black mix which we called the Violet-Blue Range. Square 2 is the starting base for Part 2, the Orange-Red Range, and square 3 is the starting base for Part 3, the Green Range.

By geometrically distorting and taking apart the surface of the hexagon, we created the three starting squares for the black mix. They are labeled with B_{00} in all three parts of this book of charts. This is because, in each starting square, we are dealing with the mixing possibilities of any two chromatic printing inks. The achromatic printing ink B is not yet represented here with any quantitative values.

The black mix is now made by overprinting the same quantity of black on each hue field of the starting square. In chart B_{10}, we thus find the same screen value of black (10%) on each hue. The black value, applying to the entire chart, can be seen in the upper left-hand corner in the hue field. This field, for example, bears the designation $B_{10}M_{00}C_{00}$ in Part 1 (the violet-blue range).

In multicolor printing, the achromatic steps of figure 15 are placed over the starting squares in this book of charts. This again is a purely quantitative system relating to the quantity of black ink applied. We find three columns labeled A, B, and C next to the tone value scale of the gray steps.

Column A gives us the designation that was used throughout this book of charts. It relates to the geometrical coverage of the screen in the film that was used for copying the printing plate. The labeling should be understood in schematic terms. In the technical execution, of course, there were deviations, which are designated in column B, where we can read off the exact subsequently measured values (with an allowance of $\pm 1\%$).

In multicolor printings, however, we must distinguish between the geometrical surface coverage in the screen

	A	B	C
	B_{00}	00	00
	B_{10}	10	21
	B_{20}	18	31
	B_{30}	29	43
	B_{40}	40	53
	B_{50}	49	62
	B_{60}	61	78
	B_{70}	69	85
	B_{80}	80	90
	B_{90}	90	95
	B_{99}	100	100

14 The three starting squares of the achromatic mix with black

15 Quantity steps of printing ink black. A = designation; B = real screen value measured on the film; C = optically effective surface coverage on paper

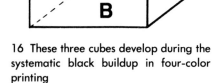

16 These three cubes develop during the systematic black buildup in four-color printing

17 Mixing components in "true" four-color printing with black structure for the three initial squares

(percentage dot value of screen surfaces, related to the total surface) and the optically effective tone value on the paper. On the one hand, the value of the geometrical surface coverage is changed in the transfer process via the printing plate and the rubber blanket to the paper. On the other hand, the tone values make a darker impression on the paper anyway than on the film due to a phenomenon which is called "light catch." We will not go into any further detail regarding this technical fact and the related situation.

In column C we find the pertinent optically effective tone value for each screen step. For the reasons given, it is considerably higher than the percentage values for the geometrical surface coverage. This value in column C will under certain circumstances be significant in deriving formulas for other mixing systems by mathematical transformation of the code numbers in the color charts.

In the meantime the reader will have noticed that the black-mix system described has resulted in a three-part color space that is presented in the shape of three cubes, shown in figure 16. Figure 17 shows the basic colors involved in this process of multicolor printing for each of those cubes. We recognize that the two achromatic basic colors white and black are always involved. This is quite logical, because the achromatic values are built up with their help anyway. The achromatic values of the hues arise from quantity components of the printing ink black in combination with the portions of the white paper surface that remain in effect. The chromatic values of the hues, on the other hand, originate due to quantity components of at most two of the available three chromatic printing inks. (The expert might be alerted to the fact that this explanation was simplified in order to make it more easily understandable, for the printing inks themselves introduce certain achromatic values into the mixtures since they cannot correspond to the theoretical requirements. Furthermore, it is basically impossible to reproduce the purity and chromatic force of all chromatic type hues with the three color layers yellow, magenta-red, and cyan-blue.)

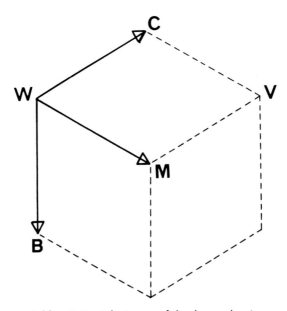

18 The three variable printing inks in one of the three cubes in case of four-color printing with black structure

Figure 17 shows how the achromatic values originate in the same manner in all three cube color spaces of the black mix, which is by quantitative variation of the achromatic basic colors W and B. The quantitative variations of two of the three chromatic printing inks are added in each cube.

Figure 18 illustrates the principle of quantitative arrangement in the cube of the violet-blue range. The point of departure is W (here the quantity is zero for all three variable components). We can interpret the arrows going toward points C, M, and B as vectors because, in the final analysis, the quantitative variation taking place here relates to the perceptive powers of our visual organ.

The surface of the cube in figure 19 is the starting square for the violet-blue range. It has corners WCVM. On the sectional planes running parallel to the surface through this cube we find hues with the same quantitative value of the achromatic

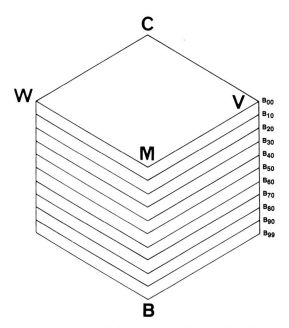

C

W

V

B₀₀
B₁₀
B₂₀
B₃₀

M

B₄₀
B₅₀
B₆₀
B₇₀
B₈₀
B₉₀
B₉₉

B

19 Quantitative arrangement of the printing ink B in this cube in case of black structure in four-color printing

basic color B. The greater the interval between the sectional plane and the surface, the greater the quantity component of B. On the base surface of the cube, the value of B_{99} is attained for each hue. Here, in other words, the full layer of the printing ink black is overprinted on every point on the paper.

This obviously means that we will be able to recognize practically no more color differences on the B_{99} charts. The manner of illustration presented here therefore has the disadvantage that there must necessarily be enormous distortions in equidistance in terms of sensation. The tip B of the hexagonal pyramid in figure 8 was, in practical terms, pulled apart into three full square surfaces. However, this insignificant disadvantage must be accepted, because it is simultaneously and necessarily connected with the advantage of an immediately recognizable and easily understood quantitative system.

20 Quantitative relationships in one of the three cubes in case of black structure in four-color printing

The quantitative formulas are given for the visible corners of this violet-blue range cube in figure 20 only for greater clarity. They are the consequences of what emerges from figures 18 and 19. If we carefully study the B_{99} color chart of the violet-blue range, we see the big difference between theory, as embodied in figure 8 by the hexagonal pyramid, and the actual practice of the printing technology. The full layer of the printing ink black alone on the field $B_{99}M_{00}C_{00}$ is, in fact, a completely unsatisfactory black in optical terms. On the other hand, the hue $B_{99}M_{40}C_{60}$, for example, is completely satisfactory as black. To enable the development of a better multicolor printing technology, the information presented here will be of interest.

If we turn away from the presently practiced three-color image buildup in multicolor printing and move on to genuine four-color printing, we gain very significant technological and

economic advantages. In the long run it really cannot make any sense to stack up unnecessary quantities of expensive chromatic inks on paper, one on top of the other, in order to produce achromatic values. Certainly we are dealing here not only with a possible saving of chromatic printing ink. Rather, the important thing is to make sure that the problems of drying and ink transfer will be reduced to the extent that the applied ink quantities become smaller. Finally, there will also be significantly less waste of paper, because the entire printing process can take place in a considerably more stable fashion. If a corresponding technology is developed, the same printer will be able to produce more and more efficiently on the same machine with the same printing inks and he will be able to arrive at better and more reliable results.

Of course, we must not conceal the fact that such an improvement in the technologies of multicolor printing presupposes a completely new approach, and that the necessary color separations cannot be made with current photographic methods. At any rate, this would not be economical. On the other hand, it can be assumed that it will be possible to produce the needed color separations with electronical technology without any basic difficulties. The color separation for reproductions with achromatic structure has to be based on the printing ink black. That means the printing ink black is most important in this reproduction process.

For the sake of completeness we might therefore mention at this point that one could visualize the development of a printing method that would represent an interesting improvement, compared to the four-color printing process just described. If we were to use all six chromatic basic colors plus black as individual printing inks, we could considerably improve the possibilities of color reproduction in the currently problematic color ranges of violet-blue, green, and orange-red. This would result in additional technical and economic advantages. To be sure, in place of four-color separations and printing plates one would have to make seven in each case. And

the paper would, of course, also have to run through seven printing units. It could, for example, be sent twice through a four-color machine. Undoubtedly, there would be a whole series of requirements and orders whose improved quality would gladly be paid for by consumers at the necessarily higher price. However, we must point out that such a printing method can only make sense in the case of the reproduction of hues that cannot be produced with this standard scale.

In the first three parts of this *Color Atlas,* the achromatic hue values are formed as much as possible through quantitative components of the achromatic basic color black. The achromatic basic color white, as we recall, was represented by the white paper surface; gray steps were produced by the interaction of black ink with the parts of the surface of white paper that remained effective.

Parts 4 and 5 of the color charts are governed by a fundamentally different principle. Here, achromatic values are produced because complementary chromatic basic colors mutually cancel out their chromatic nature and in this fashion form quantitative values for the achromatic basic color B. Those values then create gray steps through interaction with the remaining parts of the surface of white paper.

Here too, the achromatic value of a hue is theoretically made up of quantity components of the achromatic basic colors W and B. In practical terms, the quantitative components of B, however, are not formed by the achromatic printing ink B but rather by the corresponding percentage quantities of the chromatic printing inks yellow (Y), magenta-red (M), and cyan-blue (C). We expressly used the word "percentage" quantities because these quantity components are not exactly equal, as one should expect of correctly balanced inks. Instead, depending upon the color scale used and the quality of the printing inks, different quantity components lead to "absolutely" neutral achromatic values. This fact is referred to as the "gray conditions" or the "gray balance" of the inks used.

The law governing chromatic mixture, as it emerges from

the color charts in parts 4 and 5, applies not only to multicolor printing (three-color printing) but also to color photography. The difference between these two technologies merely consists in the fact that, in the case of color photography, we are dealing with so-called "true" continuous tone steps, whereas in multicolor printing the tone value steps are "simulated" by the screen pattern (halftone steps). In color photography, the particular color quantity is uniformly distributed in one layer over the corresponding surface section. In multicolor screen printing, on the other hand, we are basically always dealing with a uniform color layer thickness and the quantitative variation is due to varying dot sizes. Because the individual screen dots are so small that they cannot be individually recognized with the naked eye, we obtain the illusion of continuous tone steps. (The novice should observe the hue fields through a magnifying glass).

We must have the chromatic basic colors Y, M, and C available as transparent color layers both in three-color printing and in color photography. Note that we are speaking about transparent inks here. The achromatic basic color white is required as an indispensable foundation. In color photography it is present in the form of white light, which must pass through a color slide so that the latter's "color content" can be viewed. In multicolor printing it is—as we know—represented by the white paper surface.

In color photography and in three-color printing, the basic colors Y, M, and C are present as filter layers. Each individual filter layer absorbs a certain spectral region of white light. The three filter layers are connected one over the other and cooperate in terms of their absorption capacity. The principle behind these two technologies is therefore based on the quantitative variation of the three chromatic basic colors Y, M, and C in these three filter layers. A certain spectral region of the light is absorbed in each filter layer. Filter layer Y absorbs short-wave light, filter layer M absorbs medium-wave light, and filter layer C absorbs long-wave light.

This explains why no further light is allowed to pass through when all three filter layers are fully superimposed; one spectral region remains "trapped" in each of them. (In practice, however, this requirement is met incompletely, because the inks do not have the theoretically required qualities.)

Each filter layer "picks" a spectral segment out of the existing light in accordance with its color quantity. The rest is allowed to pass through. The individual hue thus arises as "residual light." Only the remaining part, which has not been absorbed by one of the three filter layers, can fall into the observer's eye and trigger a color sensation there.

In color photography, this residual light is either reflected by the projection screen or falls directly into the eye if one looks at a slide in front of white light. In multicolor printing, the residual light fundamentally falls first upon the white paper surface. From there it is "sent back" (reflected) and then reaches the observer's eye. On this return trip, it must of course pass once again through the filter layers.

Anyone who clearly understands this situation will realize the absolute necessity of having the achromatic basic color white. On the other hand, however, he will also recognize the significance of the spectral composition of light as regards the appearance of the hues. Last but not least, he will recognize how important the reflective ability of the white paper surface is with regard to the quality of color reproduction in multicolor printing.

In the chromatic mixture, we get quantity components of B to the extent that corresponding ink quantities are present in all three filter layers. Together with the quantity of the achromatic basic color W, which remains effective, they form the achromatic value.

Chromatic values result when surplus quantitative values are present in one or in two filter layers. This is because only those quantitative values that are not neutralized by complementary quantity components in the other filter layers can give the hues their chromatic appearance.

What was said so far clearly shows how unstable a three-color print is bound to be compared to a process involving the black mixture. The reason is that, quite unavoidably, there are quantitative variations in multicolor printing which, as we know, are referred to as "printing tolerances." These are most drastically noted where the gray balance is involved. Since all production runs are subject to such inking variations, it is not possible to produce a perfect neutral gray in three-color printing. In fact, depending upon the particular shifts in the quantitative ratios among the individual inks, the neutral gray hues will perform a "migration" through all imaginable color tints.

We can recognize the completely different principle of chromatic mix if we compare figure 21 to figure 18. In both cases we are dealing with the same starting square WCMV. In this square, the mixing possibilities of two of our three chromatic printing inks are arranged systematically.

The black mix (Part 1—Violet-Blue Range) was accomplished by overprinting screen values of the printing ink black from one chart to the next in quantitative steps of 10%. This is clearly indicated in figure 19.

In comparison to that, looking at figure 22, we can see how, in the three-color chromatic mix, screen values of the chromatic printing ink yellow are added as we go from chart to chart again in quantitative steps of 10%.

In this way we get a single cube color space that shows the systematic quantitative arrangement during the mixing of the three chromatic basic colors Y, M, and C in three-color printing. The same arrangement also basically applies to color photography.

We can see this cube in figure 23, where the eight basic colors have their places at the eight corners. We are of course not dealing here with the illustration of an ideal color space. Instead, this cube contains only those hues that can be produced by the particular process that is being illustrated.

In our case, the charts in part 4 obviously relate to the printing process used here. However, in the chromatic mixture in so-called three-color printing, we are really dealing with four basic colors. In addition to the three chromatic basic colors Y, M, and C, which, as we know, must be available as transparent filter layers, the achromatic basic color white is, as we also know, the indispensable foundation.

21 The three variable chromatic printing inks in three-color chromatic structure (color photography, color printing)

22 Quantitative arrangement of printing ink Y in the cube in the case of three-color chromatic structure

23 One of the eight basic colors is located at each of the eight corners of the three-color cubes

With these four basic colors as initial factors, the four missing ones are formed by combinations. Where two filter layers are fully overprinted we get the chromatic basic colors violet-blue, green, and orange-red. Where the three full filter layers appear simultaneously, we get black. And that happens, as was said before, in three-color printing basically in the same fashion as in color photography.

In the case of the "three-color cube," which actually should be called a "four-color cube," we are dealing with the schematic illustration of a special technical process. (The fourth color here is not the printing color black but rather the achromatic basic color white; it accounts for the remaining differential values.) Therefore the eight basic colors at the eight corners of this system are necessarily as deficient as the initial available factors, the paper and inks.

In this multicolor printing process, the basic color white is equivalent to the reflective capacity of the particular paper.

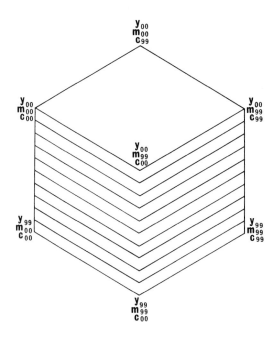

The labels on the figure, from top to bottom:

y_{00} m_{00} c_{99}

y_{00} m_{00} c_{00} (left) y_{00} m_{99} c_{99} (right)

y_{00} m_{99} c_{00}

y_{99} m_{00} c_{00} (left) y_{99} m_{99} c_{99} (right)

y_{99} m_{99} c_{00}

24 Quantitative designations in this cube in the case of three-color chromatic structure

The quality of the colors Y, M, and C depends on the capacity of the inks to absorb the complementary spectral region, on the one hand, and to transmit the remaining region, on the other hand.

The basic colors V, G, and O, which arise due to the interaction of the absorption of any two transparent chromatic color layers, are of course further removed from the ideal basic colors than the colors of the initial printing inks alone. This is because, in each case, the absorption and transmission deficiencies of the two color layers involved are added up. Hence color reproduction in the color ranges of violet-blue, green, and orange-red is often unsatisfactory in those reproduction systems.

As we know, when three full chromatic color layers are printed one on the other in three-color printing, we do not get a

satisfactory black either. The causes of this are to be found, on the one hand, in the previously mentioned gray balance of the three printing inks used. On the other hand, however, this is technologically due to the problem of ink transfer, by which we mean the fact that, during the process of transferring the printing ink to the paper, the color sequence in which we print is not immaterial. The reason for this is that the ink is best given off to the paper when it is as yet unprinted in that particular spot. The degree of ink transfer, called "trapping," however, declines if one color layer is already present. It deteriorates the less the previously applied color layers have dried. Considering the enormous speed at which four-color presses run today, "trapping" is a big problem, as anyone can well imagine. Tremendous investments and considerable energy are wasted in order, for example, to dry reasonably well the printing inks on a paper web racing through a web press during the short time available.

Figure 24 shows the quantitative formulas for the visible corners of the cube. Obviously, these again pertain both to three-color printing and color photography. The color black does not occur in the quantity components given because it after all originates from the interaction of the absorption capacity of the three transparent chromatic filter layers.

Nevertheless, the black ink today is generally used in addition to the three-color structure of image reproduction in multicolor printing. Considering the theoretical possibilities it offers, this is rather absurd. While there are no alternatives in the processes of color separation photography, there is a choice in multicolor printing between three-color structure (parts 4 and 5 of this book) and achromatic structure in reproduction (parts 1, 2, and 3).

This book adequately demonstrates that such a black structure is not only theoretically conceivable but can also be implemented in practical terms. The author's idea of systematically arranging the color charts in this fashion creates for the first time the possibility of comparing both mixing principles to each other in detail.

This will certainly be of interest not only to the printing specialist, the reproduction technician, and the manufacturer of printing inks. It also offers surprising insights for any industrial and artistic application of color. Likewise, it is simply not true that certain hues can be mixed only by "cutting" them with a certain other hue, for example, a complementary colorant.

Interesting consequences derive from color theory as far as artistic and industrial applications are concerned as well. An optimized mixing system for opaque colorants requires all eight basic colors. Here it would be meaningful to have a principle according to which the achromatic values were fundamentally formed by quantitative components of the two achromatic basic colors white and black.

Such a mixing system could be made simpler and more practical by using achromatic "auxiliary colorants." For example, in addition to the achromatic basic colors W and B, one could have available the achromatic auxiliary colors "dark gray" (D), "neutral gray" (N), and "light gray" (L). It would then be very possible to mix the desired hue by building up the achromatic value and adding the chromatic value. Here again technological as well as essential economic advantages could be realized.*

Of course, such mixing systems, built upon achromatic values, would be particularly instructive and suitable for teaching color mixing courses. In contrast to frequent current practice, the student would have an opportunity to "grasp" properly the basic laws of color theory through such systematic mixing courses. Let us hope that the dyestuff and paint industry will soon be in a position to turn out and offer sets of coordinated basic colorants. These would have to be opaque color media compatible in terms of color intensity and that

*See Harald Küppers [Kueppers], *Die Logik der Farbe. Theoretische Grundlagen der Farbenlehre,* Munich, 1976, p. 101.

would come as close as possible to the theoretical requirements in terms of their chromatic type hue.

For those who would like to put together their own three-color cube as an educational model (or, better, a "four-color cube"), we have added charts M_{99} and C_{99} in part 5. Such a model is easily made and has outstanding teaching value. Not everyone can visualize the three-dimensional nature of these interrelationships, no matter how good the explanations might be. But a three-dimensional model can be understood even by someone who cannot visualize it in abstract terms.

The individual who wishes to make his own cube model should proceed in the following manner: using strong but not too heavy cardboard (white poster board with a thickness of 0.5–1 mm), glue together a cube space that is open on one side. The inside space must be wide enough so that the color charts can be inserted like "drawers." Because the individual charts are 12 cm wide, the opening should be 12.1–12.2 cm wide. Then paste charts Y_{10} to Y_{99} on suitable cardboard. Cut them out, without code numbers, so that there is a white margin of about 0.5 mm next to the color fields. These ten color charts are the horizontal cross-section through the color space (figure 22), which we can insert and pull out like drawers. Here, chart Y_{99} is at the bottom of the inside space. On both sides, to the right and to the left of the opening, put guide bars at corresponding intervals. They can be narrow cardboard strips or matches pasted on with all-purpose glue.

Starting with figure 23, select the cube side VCGS as the opening. Then glue on chart Y_{00} as the surface. Side WCGY corresponds to chart B_{00} in part 3 of this book; side WMOY corresponds to chart B_{00} in part 2. Now all you need is side MVSO, which is present in part 5 as an additional chart, labeled M_{99}. Chart C_{99} is intended for those who would like to "close up" the cube compartment on side VCGS. However, one must take the trouble of cutting this chart apart into vertical strips in order to turn them around in sequence. The model

looks best with, for example, two empty matchboxes glued underneath as a pedestal in the middle. In this way the esthetic effect is enhanced and the geometrical shape is more easily understood.

The available opaque color media—for example, oil paints—are not balanced to each other in terms of opacity or color intensity. At any rate not yet, unfortunately. This is why there cannot be any quantitatively accurate derivation from our Standard Color Code for mixing opaque colors. In other words, we can only make general remarks, which the individual must apply to the means available to him.

It is fundamentally impossible to get the hues in the charts by mixing opaque color media yellow, magenta-red, cyan-blue, black, and white. In principle there is a big difference whether three transparent color layers are applied one after the other on white paper, where their absorption capacities interact, or whether opaque colorants are used, for the latter are first mixed and then applied in one single color layer; here the color of the base plays no role because it is covered up.

This shows that it makes no sense for us to refer, in duplicating, to the chromatic mix with the three-color structure—in other words, parts 4 and 5. We are therefore concerned only with the achromatic mixture—in other words, parts 1, 2, and 3 of this *Color Atlas*.

If we should be successful in finding the eight basic colorants (see color chart on p. 17) as suitable opaque color media, we could fundamentally duplicate all the hues in the charts with the black mix. The appearance of those eight basic colorants must merely correspond to the appearance of those eight basic colors shown in that color chart. If we manage to find color media that are equal to this color chart in terms of chromatic type hue, but which have a lower achromatic value, so much the better. They are purer and of more chromatic intensity.

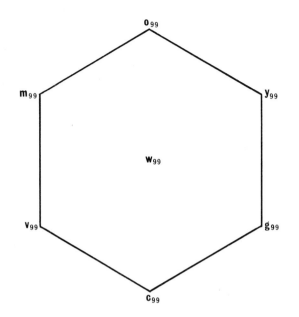

25 At the corners of the hexagonal surface we have the six chromatic basic colors. White is at the center

This will certainly be possible without difficulties in the case of the basic colors violet-blue, green, and orange-red. As a result, we would of course get a (welcome) expansion of the color space as compared to the printed color charts with the achromatic structure that are available to us.

To understand the laws applicable to opaque colorants (which are entirely different), we must again refer to the surface of the color hexagon (color chart on p. 129) and the numerical diagram in figure 4. To mix the hexagonal surface with the opaque colorants (mixing first and applying later in the opaque layer), we need the seven basic colors in figure 25 if, for example, we select a gray cardboard as the base. The hues are now no longer formed due to the quantitative blending of transparent color layers on white. Instead, a "quantitative exchange" takes place on the hexagonal surface. We must now consider each individual hue as the mathematical quantity 1 (= 100%).

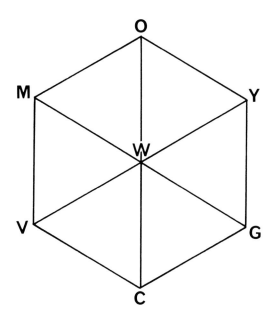

26 The hexagonal surface is broken up into six equilateral triangles by the three diagonals

The individual hue on the hexagonal surface can now be made up only of quantity components of those three basic colors which we can read off from figure 26 for each individual case. Depending on the triangle in which it lies, it can possess only quantity components of those three basic colors at the corners of that special triangle.

According to this principle it is therefore impossible for a hue to be made up, for example, of parts of W, Y, and M. It can consist either of quantity components of W, Y, and O or of parts of W, M, and O. This is because all of the mixing possibilities between Y and M are now located on the straight-line connection of these two points on the hexagonal surface. The hue that lies precisely between Y and M is an orange-red that already contains an achromatic value as a whitening factor. This hue can also be duplicated from parts of the basic colorant orange-red and the basic colorant white.

We consider the mixing of opaque color media as a

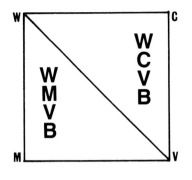

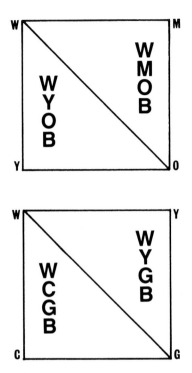

27 Each initial square of the color charts in parts 1, 2, and 3 can be broken down into two triangles when mixing opaque colorants

quantitative exchange on the surface of figure 25; we obviously are again lacking the achromatic dimension, for after all, we are dealing only with the previously described quantitative exchange among seven basic colors. Here again, the basic color black provides the missing dimension.

We must therefore visualize that the hexagonal pyramid in figure 8 is now made up of six tetrahedrons that touch at point W in figure 26. Here, in other words, we would be looking at the base surface of the pyramid. The black tip (now invisible) would be behind point W.

If we transpose this discovery to the color charts with the black mix, we are dealing with an entirely different situation than the law illustrated in figure 17. This new situation becomes clear if we compare figure 17 to figure 27.

Our color space is now no longer subdivided into the three

cubes we had in figure 16, but rather into six tetrahedrons resulting from figure 27. We must visualize each of these six triangles as the base of a triangular pyramid ($=$ tetrahedron) at whose tip we find the basic color black.

From what was just said it follows that the color space must be broken down into six tetrahedrons if we want to work with a consistent achromatic mix in connection with opaque colorants, whereby the achromatic values are made up of parts of the color media white and black.

On the basis of these discoveries, the color charts in parts 1, 2, and 3 can now be extremely helpful to us in working with opaque colorants. We merely need to visualize that each individual chart is subdivided diagonally from the upper left-hand corner to the lower right-hand corner.

The equal quantitative values of two chromatic printing inks in a Standard Color Code now point to the quantity components of the opaque color media violet-blue, green, and orange-red. Let us take chart B_{60} in Part 2 (Orange-Red Range) as an example. The hue $B_{60}Y_{70}M_{40}$ must now not be made up of quantitative components of yellow and magenta-red for the chromatic value. Instead, we need yellow and orange-red. Here the highest common quantitative value of Y and M—that is, $Y_{40}M_{40}$—points to a quantity component of orange-red, to which we add the surplus value of Y—that is, Y_{30}. From this we must conclude that the chromatic type of this hue is made up of the quantity components of the opaque color media of yellow and orange-red which have a quantitative ratio of about 3:4 between them.

We find references to the achromatic type of this hue by starting with the surface coverages of the printing color B and the remaining surfaces of white paper that remain effective (when viewed through a magnifying glass).

While the hue $B_{60}Y_{70}M_{40}$ can thus be mixed from the color media black, white, yellow, and orange-red, we need the color media black, white, magenta-red and orange-red for matching the hue $B_{60}Y_{70}M_{90}$. This is because, from the highest common quantitative value of the two chromatic printing colors, we get,

for this hue, $Y_{70}M_{70}$, in other words, a quantity component of orange-red (O_{70}) that comes together with the surplus value of the basic color magenta-red (M_{20}).

Although these last considerations might sound complicated, they are easy to implement in practice. With the available color media it is possible, by trial and error, to very quickly be able to find the diagonal boundary existing, for example, in chart B_{60} in the orange-red range. This boundary can be mixed only from the basic colorant orange-red in combination with the pertinent gray steps (achromatic values). In the hues on one side of this boundary line (that is to say, on the right, on top, in the chart), we add the basic color magenta-red, whereas in the case of those on the other side (to the left, below) we add the basic color yellow.

It must be assumed that we will do very well when it comes to mixing opaque color media after some practice, using the available charts with the achromatic mix. And anyone who works with this mixing principle in practical and systematic terms will undoubtedly derive great personal gain. By building on the achromatic value, he will learn to mix the finest desired shadings with great reliability. At any rate, he will learn that it is immaterial for the achromatic value of a hue whether it originated from quantity components of the achromatic basic colors white and black or whether it was made due to the neutralization of complementary chromatic colors into achromatic. Nevertheless, we need a black colorant that is indeed neutral and that does not make the mixed hue have a smoky tint.

In addition, it will be possible to determine accurately from the charts with achromatic structure how an unsatisfactory mixed hue has to be corrected in order to get the wanted one.

Index

About the Book:

This *Color Atlas* is a practical handbook that shows the mixing possibilities of three- and four-color printing in uniform graduations. Over 5500 hues are displayed in systematic order in 46 color charts. In the process, two entirely different methods of color mixing, the achromatic system and the chromatic system, have been contrasted and made comparable for the first time.

Each hue in the charts has its own designation, a three-part code number resembling a chemical formula. The code number serves two purposes: it indicates the mixing formula for that hue, and it "names" the hue in a precise manner. Because the color names in everyday language generally do not refer to any precise hue, but rather cover wide color regions, the Standard Code Numbers offered here can be used as a practical means of communication. The code number B30 M80 C20, for instance, refers to the precise hue that results when the following surface coverages are present in the offset films used: black 30%, magenta-red 80%, and cyan-blue 20%.

In printing this *Color Atlas,* the U.S. "Standard Offset Color References" from the American Photoplatemakers Association were used. Therefore, these color charts can be used as a reliable reference source. For instance, a color designer can use the charts to select a color, and can then direct the printer to reproduce that color by giving him the mixing formula, which refers to the quantities used in printing. Or a textile manufacturer can explain to a dye manufacturer exactly what color he wants over the phone. Also, the Standard Code Numbers make it possible to accurately indicate desired color corrections in reproduction.

This book quite deliberately is not intended as a work on color theory. The theoretical explanations were placed at the end for those readers who would like information on the basic principals underlying the system used in this *Color Atlas.* But anyone who does not (or does not yet) wish to address himself to this theory can overlook it. He will not be hindered in using the *Color Atlas* or the Standard Code Numbers. Instead, he will find it possible, by merely studying the appearance of colors in these charts, to gain an insight into the interrelationships of color order and color mixing, and to gain his own insights into color theory.

The *Color Atlas* is intended for all those who work with color—artists, printing specialists, color designers, craftsmen. But it may also be useful to art or technical educators, color scientists, industrial users of color, and all others interested in color appearance or color mixing.

About the Author:

Harald Kueppers, born in 1928, learned reproduction technology from the bottom up. He earned his master's certificate in letterpress and completed engineering studies at the Higher Technical School for the Printing Industry in Stuttgart in 1958. He is the managing partner of a reproduction company. He is also a lecturer in the specialized field of color theory. He is a member of various standardization committees concerned with color, and he is, as a board member of the Deutsches Farbenzentrum e. v. [German Color Center Corporation], responsible for color theory and communication technologies. He has become well known through his numerous articles in periodicals, and his books, *Farbe—Ursprung, Systematik, Anwendung* [*Color: Origins, Systems, Uses*] and *Die Logik der Farbe* [*The Logic of Color*] (both published in Munich). In 1981, Barron's also published Harald Kueppers' *The Basic Law of Color Theory.*